A SARDONIC CITIZEN'S

45

QUESTIONS TO APPROPRIATELY QUESTION A PRETENTIOUS POLITICAL PUPPET RUNNING VICARIOUSLY FOR THE OFFICE OF BEING TOLD WHAT TO DO IN AMERICA

CHRIS SIMMONS

www.studiohenre.com

The Imaginative Intellect of Profound Consciousness, A Sardonic Citizen's 45 Questions to Appropriately Question a Pretentious Political Puppet Running Vicariously for the Office of Being Told What To Do in America, StudioHenre, and StudioHenre logo, are trademarks of StudioHenre LLC. Black Villa Press is an imprint of StudioHenre LLC.

Library of Congress Control Number: 2020946459

Hardcover ISBN: 978-0-9967226-4-3
Paperback ISBN: 978-0-9967226-5-0
Ebook ISBN: 978-0-9967226-6-7

Printed in the United States of America

FROM THE IMAGINATIVE INTELLECT OF PROFOUND CONSCIOUSNESS™

A SARDONIC CITIZEN'S

45 QUESTIONS TO APPROPRIATELY QUESTION A PRETENTIOUS POLITICAL PUPPET RUNNING VICARIOUSLY FOR THE OFFICE OF BEING TOLD WHAT TO DO IN AMERICA

I

Do you believe the red pill is somewhat of a distant relative, if not, a direct agonizing twin of fraternal needs and political strategies to the blue pill?

II

If Viagra constitutes the moral capacity of Schindler's list and Cialis propagates jurisdiction over corporate competition, where is your movement when it comes to power?

III

There are many dangerous hulks that lie within the absurdity of their own disastrous mind-frames whenever consultation for protection turns against them; how green do you become then?

IV

frail and forgotten poster consumed viciously by the fires of hell might showcase to one how the underwhelming volumes of life's total dexterity are terribly destroyed when battling a disease's unbearable pain after constantly rubbing against the crosshairs of medicine's temporal staff, deep below the obscene waters of disgruntled patience. Thankfully though for some of these victims going through such agonizing tragedy, the chemical substances inside what's known to many as the queen of recreational gatherings, might one day cultivate spectacular powers to save the day. This hopeful saving grace to some however, is also known as an herbal vigilante to others, especially those wanting to control its use and unduly distribute it with the associated help of various puppets, including those registered in government. To you I ask, is Mary Jane the key to alternate Salvation or relentless Destruction?

V

The illusive strings that vigorously bind our pharmacy have been acquiring multiple distinctions of drug trafficking personalities inside the organized affiliations of medicinal healing. As a result, medication has undergone horrific surgery to embody the exact destruction of illegality where addiction runs rampant alongside hellish prices, thus leaving many civilians to suffer alongside health's hermetic wing, while death's deaf ear to pain, rings with pompous joy. What is your strategy for ushering in a new era of medicine without the crooked juxtaposition of agencies and associations that make up this industry's loathsome kingpin and give our nation's corrupt drug conglomerations the corporate freedom to trap us Americans?

How do you psychologically infiltrate the unsettling minds of flinching Americans who are now struggling to survive inside the discordant jungles of poverty's disparate chaos for the deniable sake of successfully annihilating their constrained nightmares of eventually becoming modern victims to an invasive 3rd world order?

VII

\mathcal{D}o you surmise the land of dragons to
be secretly ushering in a vivacious fraternity
of emblematic nations, all within one, that's
surreptitiously set to dismember the has-beens of
Superpowers known as democracy's great United
States and Great Britain's revolutionary America,
for true global authority?

VIII

Slavery steadily rubs its malicious back upon the perverted walls that firmly beget its sinful intentions within the infamous halls of Washington's District of Columbia, where Pigs and Warthog's integrate as one to hellishly sway the lives of its prey. What cologne will you cautiously muster up from the books of thieves in order to discreetly disguise your daunting scent of these dusty swine that run impeccably through your rancid veins?

IX

If you sullenly text the ambience of absolute decadence from a line of fallen heroes, why then does your heart flutter when, trumpets of war disrupt such administrative airwaves?

X

Do you think Terrorism is an overgrown callus, staunchly placed upon the deceitful toe of media's disregarded foot, by the treacherous roads of governmental nature, that's artificially created by anomalous shadows in the elite night?

XI

We ask for filet mignon but are deceptively given Donald's depressing pantry of malnourishment whenever investing in America's expensive leadership. What secret observations have your eyes succumbed to from witnessing this incriminating scene of continuing dishonesty, repeatedly served to us by political chefs of fictitious cuisine?

XII

Tasting the admirable structure of a denture's weight in gold from the underperforming potential of society's security system, grants to the has-beens of present generations, a never-ending bitterness of meaningless adventures written within the exasperating labyrinths of cracked benefits. What frantic concoction are you clearly foreshadowing to repair such an impractical disaster upon the future of this country's finances, for tomorrow's account?

XIII

With wild beasts indigenously preying upon the youthful ages of tattered dreams inside America's rapidly growing valley of nightmarish happiness, what fortified, streetwise solution do your red, white, and blue hands plan to officially form from using the green dough allowed to you by governmental statutes, legalizing such political bribery, in order to create a safer pathway for these brittle scavengers of future generations?

XIV

Like a runaway zoo locked inside the imaginary realm of predated futurists, a fabricated agenda doused in civil uncertainty is deemed capable for an unnatural surrendering of America's surreal heart. Do you wholeheartedly think the injunction of this tragedy comes from total recall? Or does preeminent fiction have factual legs from creating believable imitations of a foreseeable evolution, commonly known amongst you as propagandism?

Calvary stands at the side of the cross juxtaposed by the indecency of America's hidden shadows. What mischief speaks to you after choosing to surrender your left hand, to uphold in disguise your right, and bring about an early apocalypse for those malevolent devils, who aimlessly rage with vile thoughts of sudden dangers {already in action} to inevitably happen?

XVI

Like the evanescent bubbles coming from an animated star and his faithful sponge, how do you expect the childish perceptions of the public to rehabilitate the necessity of an American dream, when eyelids remain open to the eye of carelessness, known truthfully as the American government?

XVII

Do you smell the daffodils of complete annoyance from the chaotic cheese puffs that intoxicate the resistance of civilians desiring a new guardian for their bastardized state of mind?

As such rulers begin to interject venomous threats to the members of their forsaken nation, a mind of vast land becomes a threat to the once chosen one. How are we to consider such competition not a direct copy of what such shadows in the dark fantasize about and work so vehemently for to bring upon America's 'unattainable' table that so stubbornly burns away, in its own virtueless circle of flames?

XIX

onstipation can bring utter silences of improper constraint to the vessels of our deepest treasures. Because such stress is unhealthy to the body, what is your solution to keeping the body of this constipated country from further constipation, and even further, finding this country a proper release?

XX

Asses are tasted by many tongues of weak fortitude. In order to provide a proper addendum of sovereign strength, please bring forth a list from your spotted tongue of how many asses have seasoned your tongue thus far in the game.

XXI

Chimpanzees mindlessly attack each other against the walls of their cages as they transcend various states of animalism forcefully brought upon them by the monstrosities of inhumane experimentations. A percentage of one deems this valuable as they continue such psychological research to thoroughly captivate the minds of many and mentally instill within them furtive instructions for randomly performing rambunctious behaviors that could prophetically initiate the predetermined horrors of civic penitentiaries tucked behind the glass of states encasing the neighborhoods living within them once martial law breaks. Are you allowed to speak out inside a civilian bubble using words that's governmentally based upon your take of their desire to change humans into confined primates? Or are you conspiratorially captivated to do otherwise?

XXII

LSD was thwarted by the heinous roosters who crowed its lethal injection onto morning's delight, once such drug use was deemed too boring for human subjects under experimental use. While the FDA funneled this improper noun as unsafe to the subjects' outside classmates, the CIA allowed it safe for the continuation of industry-driven musicians and programmed rebels alike. What drugs do they specifically give you?

XXIII

Slime was once known to be an ejaculated fragmentation of ectoplasm from frantically charged apparitions. Now however, reality has shown this disgusting structure to be a disruptive toxic, slyly conceived from the waste of meat factories and purposely used as nutritious food for society's breeding. How do you constitute the allowance for our homeland's populace to be fed such petrifying vomit?

XXIV

child's belly dreams wildly of atrocious chemicals due to a higher power emanating from media-warlords ingraining a falsehood of magical printings that suggest such an intercourse of chemistry and artificial structuring to be real nourishment. With nutrients being the holy grail of growth, what experience do you have in the kitchen to combat such graphical crack?

XXV

Procreation has been turned into a circus act for the public to engage in by the corporate hands of destructive negotiations. What do you propose in order to properly annihilate such whorish attitude inside a nation foolishly blanketed by the skins of porneia?

XXVI

Do your actions speak with
the submissive character of a milked cow or the
expansive subtlety of a sleeping chicken? If these
do not address the permissible natures required of
you for this upcoming role given to you,
then what gracious animal of domestication
accurately will?

XXVII

Like a baby with a mouth full
of sugary pudding, what gibberish bullshit do
you plan to happily endorse from your tongue
of immaturity that's so spiritually in conjunction
with the other babies playing upon
your playground?

XXVIII

With War heroes rising from the grounds of training and falling to the ashes of sacrifice, a depressed state of treasured memories is the only peace of mind that comes home. How do you explain the benevolent access of moral treason this country is allowed to bestow upon its beloved citizens, who happen to be continuously manipulated by a dirty institution dictating contradicting definitions of equality and freedom?

XXIX

Pigs repulse the emblems of mutilation, but take drastic measures when falsifying important artifacts for the selfishness of it. From the improper looks of you carrying savage qualities from your wildlife parties, what callous agenda runs underneath your mischievous hide?

XXX

If you fly a kite onto the geometrical figure of a pentagon, nature's impeding fraction would show to the eye fire from the sky and justification for retaliation would be protection of boundaries to the public ear of many. While a majority use their eyes to bat the issue with captivating games of baseball, few actually assess these public results and reach for further access. With 1984 becoming a brave new world, what will your impending actions be for these thoughtful people who thoroughly question everything during your reign of imposed terror?

XXXI

Sometimes my boss premeditates legal jargons of diminishing pipe dreams to the depths of my heart, but when it's time to confess their existence, he is at arm's length with another Pope giving me the bird. How can the falsified magic from your magician's hat straddle such problems of hypocritical moments from those corporate holes of backhanded asses?

XXXII

Horror stalks the engines of media's mediocre front lines miles away from its Hollywood cousin of film and stampedes into the generated minds of many, nimble words of corruptive hypnotism that come from the robotic broadcasters whose operators happen to be the controlling hands of this country's controlled syndicate. Feeding inane terror of scripted teleplay into the general mind's carefully calculated brainwaves, has allowed the box office to authorize unnecessary invasions within the known scope of our lawful privacy. What is your thematic conclusion to these fictional realities of intense control that are disguised to us as necessary weapons in order to combat the inane terror of this simulated horror?

XXXIII

Do you understand that forcefully evaluating a dog's water, will intentionally ignite his appetite for thirst-quenching liberty? Or is it because your vision is of the insensitive dog catcher that you could really give two shits?

XXXIV

If we can functionally initiate the declaration of an evil ally's international power sphere by hedging unwanted debts toward their leader's palace of slavish assistance, what can you do to stop our land from becoming nothing but a forced economical intern of diplomatic harassment to other countries?

XXXV

If drug magic funnels the true antiquities of pharmaceutical symphonies, then medicinal qualities were the budding substances in its vehicle of healthy associations for paid transactions. With this revelation, a justice of reason quantifies the reports of many to be abusing and overdosing upon healthcare's legal dosage of bodily indelicacy. Do you have the corporate stamina to crackdown on this fallen foundation of spellbinding remedies that beguile the fields of health? And if so, what spatula of strategy will you improvise with to devoutly battle their enchanted wand of enticing witchcraft?

XXXVI

Oh no say it isn't so! The once heroic doctor has now become a vampiric vessel for Count Pharma and does nothing but suck the financial life out of patients with the admonished assistance of sinister insurance. With the world of health completely going under, what is your salutary action for ridding this sick land of such unholy monstrosity and rightfully returning the correct care of health back to America's endangered humanity?

XXXVII

As rights are continuously robbed from the womb of democracy's predetermined motherland, the will of standing down grows imminent with embittered resistance. To which indecent trip of thievery will your appointed petals of opulence allow the hang tags of your constitution to render no more for this social injustice?

XXXVIII

An astonishment of pride stalks the chickens that flock the rooster's political nest in the apple of Washington's thoughtless eye. With sweetened pride comes a soured taste of spoiled brats that have grown blind to the evil twins known to the world as treasury and ignorant riches. Now that earth's prodigious curves are proclaiming a wrap around to complete history's inglorious antiques of fallen bejeweled empires, America's bell grows ever sharper for monumental judgement. What thoughtful request of poignant conceit can you render inside the closed ears of greedy elephants and sorrowful slaphappy jackasses that'll permeate their thickheaded layers of integument and fully acknowledge the preemptive attack on America that is occurring from the minds within it?

XXXXIX

So where the intrusions of mustard conceal drops of ketchup, so it is with the nature of elite representation inside the home of politics. With moles engulfing the government's skin tone, the invaluable light for truth's vital nutrients has been artificially blocked out. How will you position your doctors to save what's left of the government's untouched skin from the upcoming dangers of structural destruction, fundamentally caused by false illumination?

XL

With the future of deluded souls walking the oily planks of Wall Street and drowning in its sea of financial greed, how will you wreak hellish havoc upon the rapacious beast of nickels and dimes?

XLI

Can you explain the sudden expertise of your joint enchantments with the thunderous notions of precarious acquaintances throughout your adventurous timeline and how those secretly, yet publicly intertwined contributions of non-profiteering, will profit you and this nation under your exaggerated rule?

XLII

Something routinely smells of periodic imprisonment from the prejudicial nation of stereotypical justifications that wrongfully represent, what Americans desire. Are you of citizenship from this horrible nation that brings so many inhabitants from its ancient land here to control us? Or is your competitor the continuing transgressor?

XLIII

\mathcal{I}f the supreme law does not
assemble nor concede to demigods, why then, must
the people of this land, be treated sacrificially to the
constitutional tyranny of multinational autocracy?

XLIV

Apricots of impersonation falter in the worst setting when the cheese of its pits smell more of cinnamon than the coating of an apple pie roasting in an oven's trenches. If the vile cerebellum behind its coated skin reverses an antidote of repercussion after following precious orders from the veiled springs of underground's authority, then the avalanche of peaceful prosperity is overthrown by damaging infirmity. As the seasonings of this political dish smell of scents that reposition each other to be fraternally the same twin, reasoning becomes touched by thought that there within the mud puddle of doubtful slinging, lies the same agenda mirroring the opposing sides of its generators. Do you consciously allow the misguided disguises of apples and oranges to decorate your silly faces because the nation is silly for believing in such a false act of social entertainment that's craftily branded to us as politics, while cleverly including within its fallacious package, a pernicious set of fan club memberships created separately as different political parties for the sole purpose of perpetuating national disunity?

XLV

The nefarious fact that farts have only a limited amount of time to express themselves before necessarily expiring can showcase to one's mind just how much time is of an important essence for the scoundrel of political flatulence, known to the citizens as you. How do you conclude your persuasion then regarding why you should reign as the next puppet for the systematic governance of shadowed puppeteers?

"Awake my citizens,
for you are and continue to be,
foolishly led and despicably deceived."

-A Sardonic Citizen of Disillusioned Proportions

Goodbye for now...

Up next...

Sir Henry's

$HRÆWD

QUOTATIONS

OF AN

INGENIOUS

Intellect

coming

2021

Follow Chris Simmons, The Imaginative Intellect of Profound Consciousness Series and more:

Twitter:
@chris_simmons

Instagram:
@chattingwithchris

BLACK
VILLA.
PRESS

CPSIA information can be obtained
at www.ICGtesting.com
Printed in the USA
LVHW041047091120
671124LV00007B/163